T0067055

Possums Are NOT Cute!

Possums Are NOT Cute!

And Other Myths about Nature's
Most Misunderstood Critter

ALLY BURGUIERES

QUIRK BOOKS

PHILADELPHIA

Copyright © 2022 by Alexandra Burguieres

All rights reserved. Except as authorized under U.S. copyright law, no part of this book may be reproduced in any form without written permission from the publisher.

Library of Congress Cataloging-in-Publication Data

Names: Burguieres, Ally, author.

Title: Possums are not cute! : and other myths about nature's most misunderstood critter / Ally Burguieres.

Description: Philadelphia : Quirk Books, [2022] | Summary: "An exploration of opossums, including a guide to opossum anatomy, facts that contradict common myths about opossums, and anecdotes from the author's experience rehabilitating wild opossums"—Provided by publisher.

Identifiers: LCCN 2021042957 (print) | LCCN 2021042958 (ebook) | ISBN 9781683692997 (hardcover) | ISBN 9781683693000 (ebook)

Subjects: LCSH: Opossums—Physiology. | Opossums—Behavior.

Classification: LCC QL737.M34 B87 2022 (print) | LCC QL737.M34 (ebook) | DDC 599.2/76—dc23

LC record available at https://lccn.loc.gov/2021042957

LC ebook record available at https://lccn.loc.gov/2021042958

ISBN: 978-1-68369-299-7

Printed in China

Typeset in Clarendon, Gelica, Multi, Menco, and Cherry Pie Script

Designed by Elissa Flanigan

Full photo and illustration credits appear on page 128.

Production management by John J. McGurk

Quirk Books

215 Church Street

Philadelphia, PA 19106

quirkbooks.com

10 9 8 7 6 5 4 3 2 1

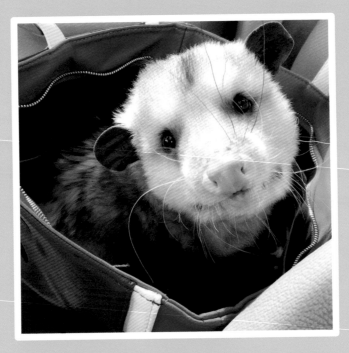

**For Sesame, and for all those
who loved him along with me**

Contents

Author's Note

My hope is that this book will inspire an affection for possums and encourage people to care about them in the wild, rather than think of them as pets. All of the possums within these pages have been photographed in a wildlife rehabbing or wildlife ambassador context. The goal of rehabbing is to rehabilitate and release an animal back to the wild. Occasionally, a possum with lasting injury or genetic disability cannot be reasonably expected to survive in the wild, and in some of these cases they may serve as a wildlife ambassador. Wildlife ambassadors educate people and advocate for their species while living out their days under specialist care. With this care, ambassadors can live dynamic, funny, full lives, and, in the process, touch the lives of others. They can inspire hundreds of thousands of possum advocates and fans, leaving a legacy that makes life easier and safer for their wild kin.

If you encounter an injured possum or any orphaned baby less than seven inches from nose to rump, please contact a wildlife rehabilitator immediately. Possums have complex dietary and medical needs, and experts have the knowledge and tools required to help. Even if an orphaned baby appears healthy, their well-being and survival depend on receiving this specialized care. Adopting a possum as a pet is extremely dangerous for the possum and illegal in many states.

I hope that the stories on these pages and the possums in these pictures—the babies who have been released to the wild, the wild ones who stopped in for some first aid, and those who shared or are sharing their lives with humans to educate and advocate—will shine new light on this misunderstood species. Few animals are plagued by as many myths and misconceptions as the possum, and I hope that dispelling these notions will usher us into a new era of possum appreciation. As you'll see in the pages ahead, there are few animals as remarkable and unexpected as the possum. We owe it to them and to ourselves to respect how wonderful—and wild—they are.

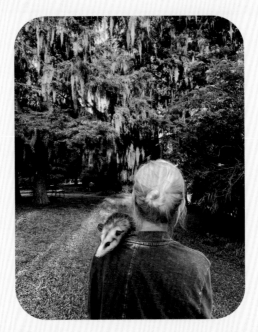

Introduction

The first time I saw a possum up close was through the glass door to my parents' back porch in Bethesda, Maryland. I'd seen possums before, but this was different: we were face-to-face with just a foot or two between us. He crunched our outdoor cat's kibble while I studied his features by the porch light. His head was wider than his body and one ear was missing. A long, beige tail drooped at his backside, and at his front, a mouthful of teeth shone like daggers. His whiskers grew in zigzags from his muzzle and forehead, and his fur was tousled in all directions. I felt a pang of affection seeing his carefree enjoyment of a midnight snack—the reason I was awake, too. But everything I'd heard about possums rushed to mind: they're diseased, dirty, mean. I turned off the porch light to give him his privacy, and for years I never questioned the harmful myths that plague his species.

Decades later, I had about as much to do with possums as most people do, which is nearly nothing. I had completed my PhD in linguistics, was teaching with Tulane University, and had begun working as an artist and business owner. I loved animals and took every opportunity to incorporate them into my life: painting them in my art, supporting animal rescue organizations, committing to a vegan lifestyle, and even working as a vet tech between grad school degrees. As far as I was concerned, every animal could be cute if you gave it a chance. But possums?

Then one day, I got a call about a possum in need of help. Wondering if my small car was big enough to hold a snarling beast that I thought would be in a large kennel, I apprehensively said yes. As I pressed my phone to my ear with my shoulder and tried to clear the clutter from the backseat, my friend gave me a truly pitiable rundown of the struggles this possum faced. He had been taken in as a pet (bad idea—see page 110), and when it was clear he was suffering, likely from malnutrition, his owner dropped him off with a possum-loving friend who promised to find a wildlife rehabilitator. In the thick of baby season, all the local rehabbers and wildlife centers were too full for new intakes. The friend's last call was to a rehabber who knew me—and who knew I wouldn't have the heart to say no. Helping out sounded temporary. A momentary excursion outside my comfort zone. I got into my 1971 Elm Green Volkswagen Beetle and started driving toward the animal that would change my life.

The GPS directions led me to an RV park, where a friendly woman invited me inside an adorable "glamper." She shared that she used to be a Texas beauty queen and rummaged in her fridge for a fruit cup while I slid into the booth of the kitchenette. Looking around for a kennel, I noticed a crocheted possum plushie on the bed and a possum-print valence over the glamper's window. She sat down across from me, placing the fruit cup between us, and then I saw the possum. He was tiny—the size of a gerbil and missing a few patches of hair—and he emerged from the zipper of her jacket, making a beeline for the fruit. The possum sat up on his haunches, holding the plastic cup with one hand and sorting

through the diced fruits with the other. "Don't worry," she said. "It's in juice. I wouldn't give him the syrupy stuff." He found the unnaturally colored cherry he was looking for. Every time his mouth closed to chew, it formed a smile that beamed pure bliss.

Twenty minutes later, he and I were in the Beetle, trusting its two working cylinders to get us home. The baby, whom I later named Sesame, stayed nestled on my shoulder as we sputtered along. I sang to him quietly while I reconsidered every thought I'd ever had about possums.

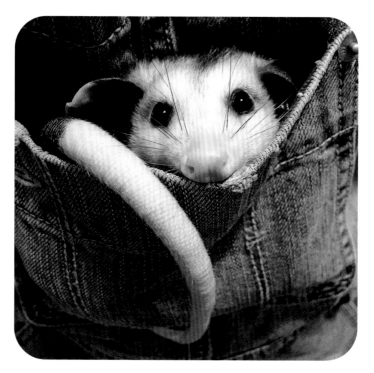

Once settled at home, I dived into every resource I could find on how to care for his species, all the while unsuccessfully seeking a more experienced caretaker for him. With the help of a veterinarian, I followed a diet and care regimen designed to treat his malnutrition, keeping a close eye on his progress. With each passing day, I fell further for his impish, trusting personality. His dark boba eyes, brimming with unending depth, took in everything. They also never let me out of his sight, which is a problem for an animal who is meant to be wild. If I tried to give him space, he'd run up my pants leg and settle right back into the spot he'd claimed on our first ride home. Just as unexpected as our mutual affection was the information I was learning about possums; it ran counter to everything I thought I knew.

Not only are possums the United States' only native marsupial, they've also contributed to the country's ecology, history, and culture in outsized and unexpected ways. They've been around for sixty-five million years—appearing just as the dinosaurs went extinct—and their physiology is completely unique. They were kept as pets in the White House by multiple US presidents. They're also environmental heroes who benefit humans and the world around them by eating cockroaches, ticks, and venomous snakes. And they do all this in the shadows—both literally and figuratively.

At the time I was getting to know more about Sesame's species, a positive mainstream conversation about possums was virtually nonexistent. My online search for *opossum* returned a gag gift of canned possum and some unflattering photos of surprised

specimens. Digging a bit deeper, I found Heidi the Cross-Eyed Opossum (whom we'll meet on page 51), though by that time she'd passed from old age and popular attention had turned to the next viral animal celebrity. A few newsy opinion pieces advocated for possums by insisting they're "not that bad." The more I searched for pro-possum content, the clearer it became that possums were ripe for a renaissance. (I've since found the National Opossum Society and the Opossum Society of the United States, both wonderful organizations I love; my Google algorithm at the time, however, hid them from me.)

While his skin, fur, and overall health improved, Sesame was permanently affected by his early upbringing in one important way: he had neither the disposition nor the desire to be wild. He refused to show any interest in the activities—bug catching, outdoor sleeping, hissing at humans—that would help him survive on his own. After learning about possums' vibrant lives in the wild, I had hoped he could one day eat ticks, fall in love, and make sesame seeds (babies of his own). But it became clear he wouldn't survive if released. I consulted with a rehabber friend, and she suggested he would make a great ambassador for his kind. If I had been so mistaken about possums, there must be others like me out there, and perhaps Sesame could help them discover an unlikely friend who'd been there all along. Sesame and his possum advocacy found an audience on social media. As his life went online, Sesame's friends grew to thousands, then hundreds of thousands. His inbox overflowed with love letters, fan art, funny

stories, and—my personal favorite—testimony about how he completely changed people's opinions on possums.

Sesame inspired me to learn everything I could about possums, and in the time since he passed from old age I've honored his memory by rehabilitating and releasing hundreds of orphaned or injured possums. The goal of rehabbing is always to release healthy and self-sufficient individuals back to the wild, where they can enjoy their rightful freedom and autonomy. In some instances, injury or genetics will cause an animal to be non-releasable, and in special cases these animals can be wildlife ambassadors, advocating and educating on behalf of their species. Regardless of their individual circumstances and personalities, every possum is a reminder of what I never guessed while studying the old possum on my parents' porch: they're shy, gentle, funny, and really freaking cute. Moreover, they enrich the planet and human lives in ways we'd never expect.

So this is for them, for you, and for anyone seeking possum positivity: an entire book dedicated to defeating the negative myths that have plagued possums for too long. The easiest myth to defeat—the one that Sesame corrected for me as soon as his whiskers caught wind of a fruit cup—is that *possums are* not *cute*. Nothing could be further from the truth. Need proof? Just ask the possums in the pages ahead.

First and foremost, possums are wild. But possums who live as wildlife ambassadors have a knack for showing just how cute these animals can be.

I once spent forty minutes trying to convince a class of nine-year-olds that the possum in my hands was the same species as the possums in their backyards. "This one's a different kind," they insisted as I told them again that she's a Virginia opossum, the one and *only* kind that lives in the United States. They all agreed that couldn't be true. "I've seen a possum before," one girl said. "This isn't the same. This one is . . . cute."

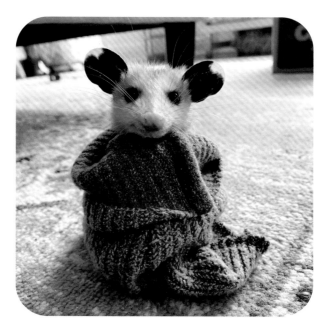

A "purebred" possum from a super-secret stock of super-cute possums. Just kidding. This is a regular possum.

This is the same kind of possum that might be in your backyard. If anyone ever tries to tell you that "normal" possums aren't cute—here is your counterargument!

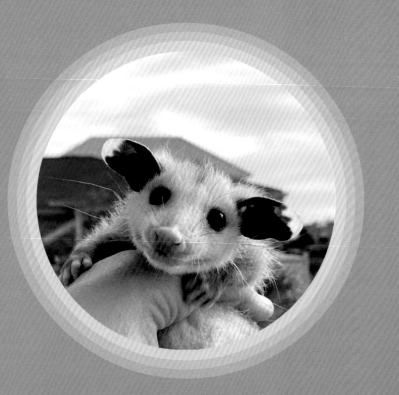

You can also show them this picture.
Anyone who's not convinced is a monster!

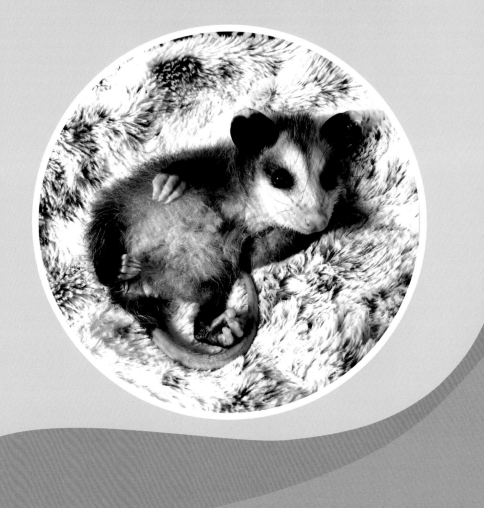

How dare the haters deny this saucy smile.

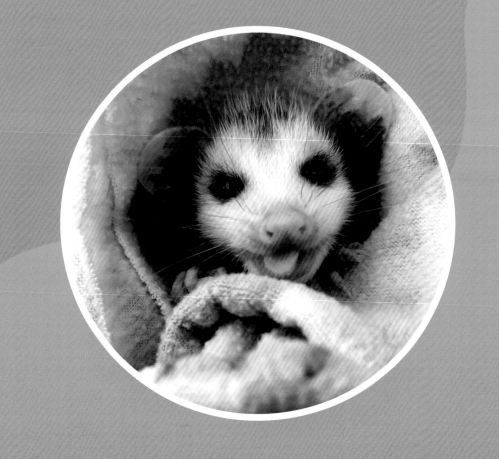

Or this sweet snout.

Far from being mean or aggressive, possums are simply shy. They're the introverts of the animal kingdom. If they're nervous—which is often the case—they have two modes: hiding and screaming. Hiding is something they're good at.

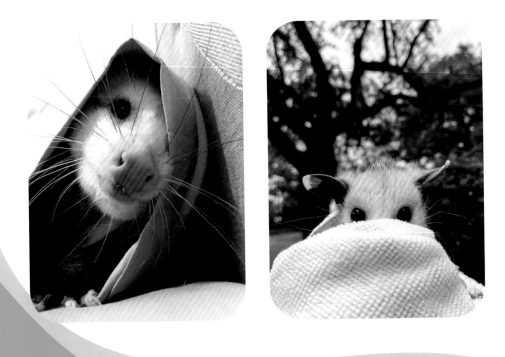

And screaming is something they're *great* at.

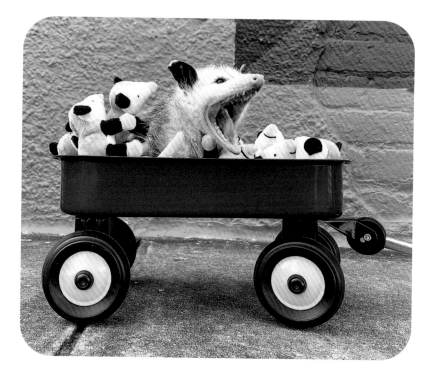

If a possum can't scream (or growl, or hiss) their way out of an un-wanted situation, their fight-or-flight response kicks in and they choose neither. Instead, they faint. "Playing possum" is not actually skillful acting, but rather an involuntary response to fear. Sudden anxiety can knock a possum out for several hours, during which time they'll appear dead in a reflexive last-ditch effort to be ignored and left in peace (see page 84 for all the weird details).

But when they're comfortable enough around you to stay conscious, possums are loyal and generous friends.

"HERE, HAVE SOME VEGAN MARSHMALLOWS."

They're filled with happiness, confidence, and joie de vivre.

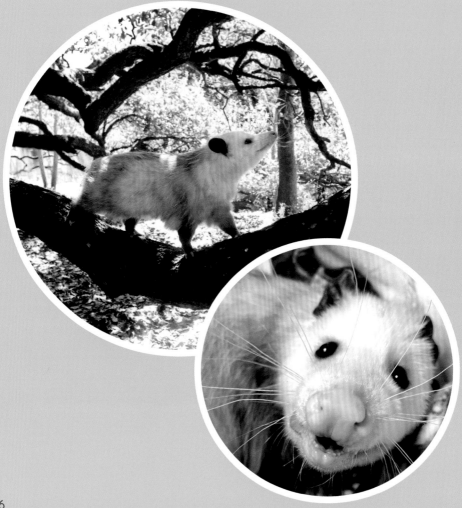

Easygoing, open-minded, and very Zen, possums are nature's original flower children. And because they eat ticks, trash, snakes, cockroaches, and more, they keep the planet clean and even protect humans from disease.

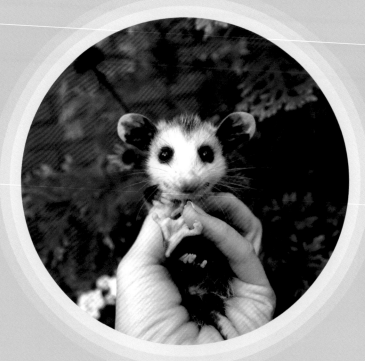

Connoisseurs of cozy, possums appreciate the comfy things in life—like a good pouch. They are marsupials, after all, a group of mammals named for the pouches in which they raise their young.

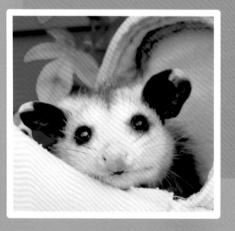

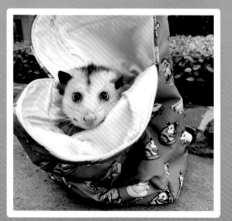

Though possums have a reputation for being loners, they love to hang out with other possums (as long as they still have enough alone time). A group of possums is called a *passel*.

Possums are always down to have a good time.
Wildlife ambassador possums much prefer
playing dress-up to playing possum.

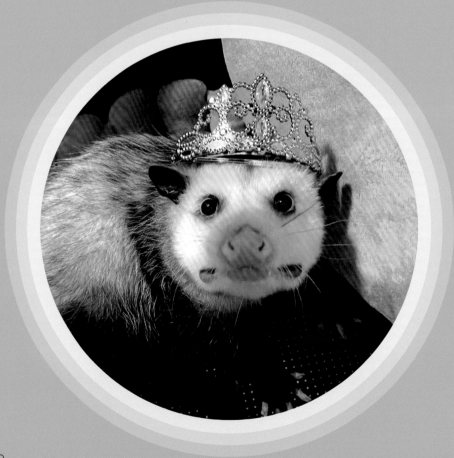

They also love a good tea party.

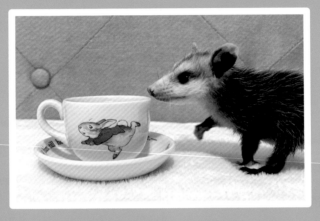

(And a good tea *pot*.)

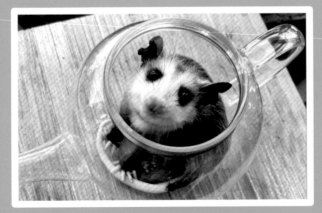

Having a birthday party? Say no more!

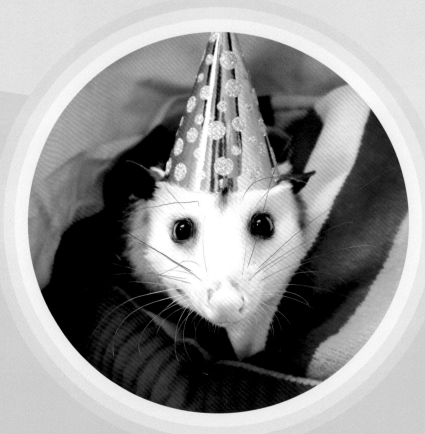

Need a wedding date?
These cuties have you covered.

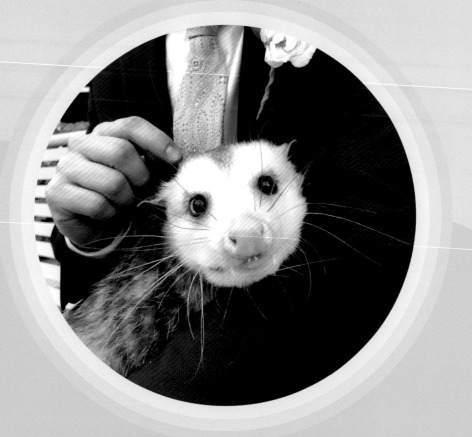

Looking for a travel buddy? Possums love to discover new lands. Fossil evidence suggests that ancient possums originated in North America and waddled their way around Europe and East Asia before settling back in the Americas.

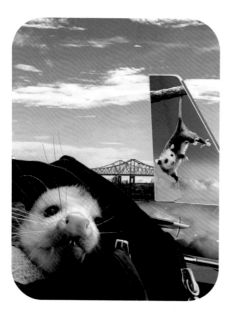

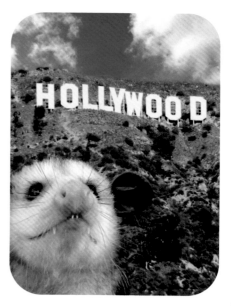

Although the possum is native to the eastern United States and is expanding its range into Canada, humans intentionally introduced the species to California in the late nineteenth century for ranching. They are now established left coasters.

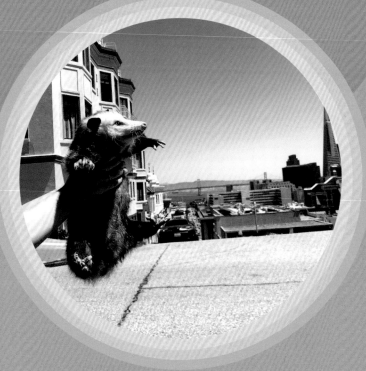

Planning an outing more casual and closer to home? How about a picnic at the park?

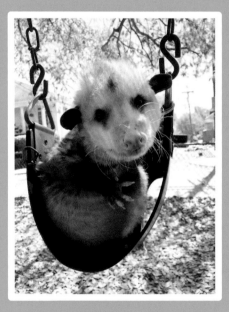

If you're more the homebody type, possums are perfectly happy to stay in and snooze the day away. In fact, possums are generally nocturnal, like many of their fellow introverts.

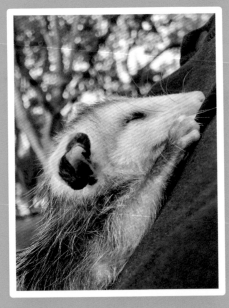

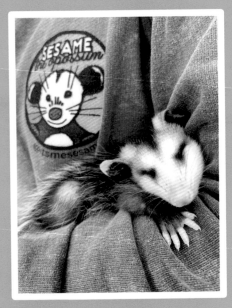

Truthfully, you shouldn't *actually* take possums on road trips or invite them to birthday parties. The cherubs in these pictures are either growing and preparing for a life in the wild or are non-releasable wildlife ambassadors. In fact, there's a section in this book on why possums should *not* be kept as pets (see page 110).

But that doesn't mean we can't appreciate them for everything they are: wild, cute, unique, good-natured, and good *for* nature, just to name a few of their wholesome qualities. In short, possums are a gift to us all.

IMPOSSUMBLY FASCINATING FACTS

The Possum Monument

In 1982, a twelve-foot-high Possum Monument was erected in Wausau, Florida, celebrating possums' contribution to human survival during times of need, as well as their general "magnificence." The monument praises possums for providing for humans in ways I'm sure they would have opted out of if given the choice. Still, it shares some complimentary words about the species ("flavorful" notwithstanding). The monument remains to this day and is engraved with the following:

Erected in grateful recognition of the role the North American possum, a magnificent survivor of the marsupial family pre-dating the ages of the mastodon and the dinosaur has played in furnishing both food and fur for the early settlers and their successors. Their presence here has provided a source of nutritious and flavorful food in normal times and has been important aid to human survival in times of distress and critical need.

While it's nice to see a monument to possums, surely they deserve to be recognized for more than being ancient and edible in a pinch. Imagine a twelve-foot-high bronze possum, heroically carrying her family on her back for all to see and admire, above a plaque detailing possums' perseverance and parental dedication. Now that is a possum monument I (and many possums) would like to see.

Possums
Are
NOTHING
Special!

While many people view possums as ordinary, boring pests, their unique anatomy actually makes them unlike any other creature on earth.

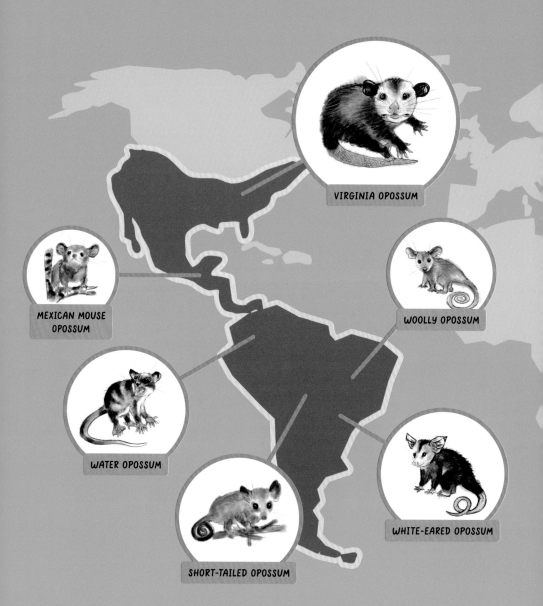

VIRGINIA OPOSSUM

MEXICAN MOUSE OPOSSUM

WOOLLY OPOSSUM

WATER OPOSSUM

SHORT-TAILED OPOSSUM

WHITE-EARED OPOSSUM

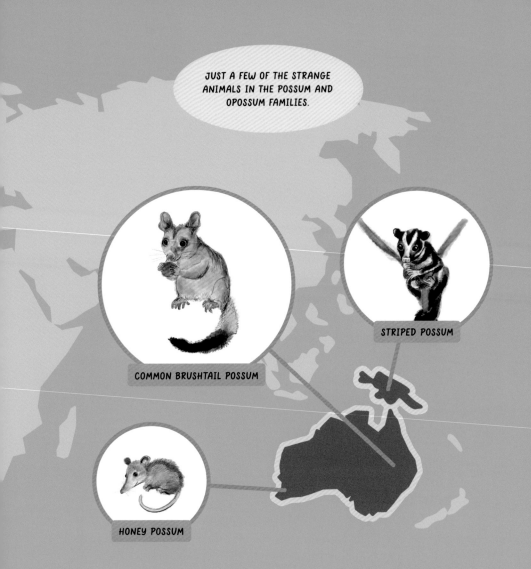

Before we dive deeper into how special (and strange) possums are, let's agree on exactly which animal we're talking about. Technically there are **POSSUMS** and there are **OPOSSUMS**. The former are found in Australia and nearby islands, and the latter are found throughout the Americas. There are over seventy species of Australian possums, and over one hundred species of American opossums, all of which live south of the United States, with one exception: the Virginia opossum (the formal term for the species we're exploring in this book). The Virginia opossum can be found as far north as Canada and as far south as Costa Rica.

So why do so many people (and this book!) say *possums* when what we mean, technically, is *opossums*? The ambiguity and interchangeability between these names can be blamed on naturalist Joseph Banks, who visited Australia in 1770 and, familiar with American opossums, wrote that he had discovered an Australian animal "of the opossum kind." Centuries of study since have made it clear that while both groups are marsupials, the animals are only distantly related, even though people in both Australia and the United States have used the terms interchangeably. Seeking clarity, in 1947 naturalist Ellis Troughton implored society to exclusively use *opossum* for the American species and *possum* for the Australian species. But his plea was ignored. Most Americans (myself included) write *opossum* in technical settings but treat the "o" as silent in conversation. Sacrificing a bit of technical clarity in favor of familiarity, we're going with the established nickname *possum* in this book. Apologies to Troughton.

Having clarified that, let's consider the possum's spectacularly strange and unique anatomical composition.

Without reference points to understand these strange beasts, the earliest descriptions from Europeans who encountered the marsupials for the first time painted them as chimeras, monstrosities patchworked from the scraps of other fauna. In 1516, Peter Martyr, counselor to King Ferdinand of Spain, encountered a Brazilian possum that Vicente Yáñez Pinzón (commander of Columbus's ship the *Niña*) "gifted" to the king and queen. He described the creature as

> *that monstrous beaste with a snowte lyke a foxe, a tayle lyke a marmasette, eares lyke a batte, handes lyke a man, and feete lyke an ape, bearing her whelpes abowte with her in an owtwarde bellye muche lyke unto a greate bagge or purse.*

**THAT MONSTROUS BEASTE
WITH A HEADE LIKE A COWE.**

In 1612, English colonist John Smith wrote of the Virginia opossum, observing that "an Opossum hath a head like a Swine, and a taile like a Rat, and is of the bignesse of a Cat." It seems there was no animal whose parts could not be repurposed into some feature of the possum.

Eventually there were those who gave up making comparisons altogether. In 1909, a member of President William Taft's Possum Committee (more on that on page 76) told a reporter from Georgia's *Worth County Local* newspaper that

"a possum is not like anything else under the sun, except another possum."

What were these fantastical parts that no one could describe without crafting a frankencreature? Let's get into it!

Noses

One feature that is 100 percent possum—unlike any other animal's—is the pentagonal possum nose. It's a first-class food detector with 1,188 olfactory genes, a whole lot more than the 396 humans possess. In fact, possums have the third most effective sniffer in the animal kingdom, losing only to rats, who have 1,207 olfactory receptors, and African elephants, who have 1,948. When possums are first born, tiny and defenseless, their

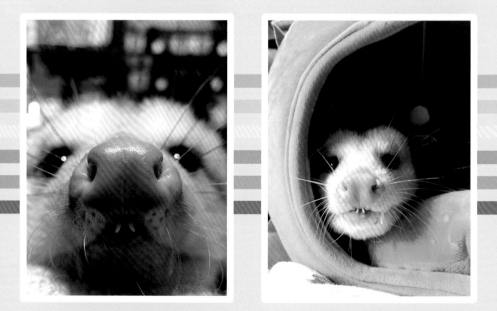

extraordinary sense of smell is almost fully developed and crucial to their survival—it's how they follow the path their mother licks for them from the birth canal to the pouch. Because possums are primarily nocturnal, their amazing noses help them find food even in the darkest nights (and for the omnivorous and opportunistic possum, virtually *anything* is food).

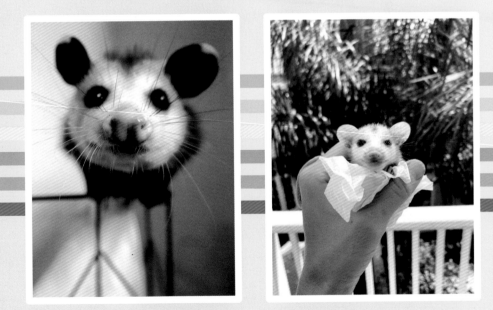

Eyes

Possums are commonly thought to have poor vision, but in fact their eyes are highly developed. Along with primates and carnivores, possums have something called *beta retinal ganglion cells*, which allow them to stabilize moving images on their retinas, giving them the ability to visually track moving prey. If you ever see a possum catch sight of a bug or lizard, you'll be amazed at their quick reflexes and hand-eye coordination (they'll often grab prey with their hands). The retinal blood vessels of possums and other marsupials are also arranged in pairs, creating a structure completely different than that of any other mammal. Researchers have speculated that this paired retinal vasculature may have evolved from an ancestral reptile.

And we can't ignore one eye fact you don't need a microscope to see: some possum peepers are veritable googly eyes! Possums, particularly females, store fat behind their eyes, which may be the source of the poor eyesight myth. These fat pockets are what cause the cross-eyed look that is so common in nonwild possums, such as those who live in zoos or are educational ambassadors. Why are nonwild possums more likely to accumulate body fat? It's a combination of decreased exercise, increased access to food, and living long enough to show signs of old age (because wild possums typically have drastically shorter lifespans).

Like anyone, possums are not immune to the siren call of a cushy bed and prepared meals.

One possum even became famous for her cross-eyed aesthetic. The same Heidi I had come across in my early research, Heidi the Cross-Eyed Opossum was a resident of Leipzig Zoo in Germany who went viral in December 2010 when a tabloid photo of her garnered international admirers on social media. Media savvy as she was, she parlayed her moment of fame into a YouTube song, a plush likeness, and an extremely popular Facebook page.

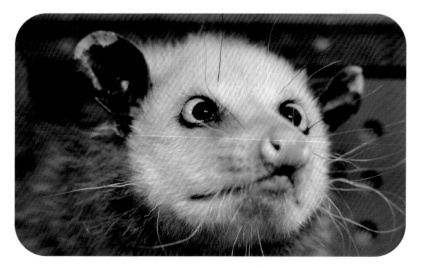

HEIDI THE CROSS-EYED OPOSSUM SHOWING OFF HER FAMOUS PEEPERS

Whiskers

Possums have an impressive spray of long whiskers called *vibrissae* that can grow up to twelve inches long. Each one operates independently and connects to nerve endings that are extraordinarily sensitive, allowing these whiskers to serve as important guides to the physical world during bug hunting and tree climbing. By helping them sense movement and navigate through dense branches, a possum's whiskers are just as important as their eyes (and perhaps even more so on especially dark nights).

While they're absurdly long and at times unruly, there's no denying that whiskers are one of possums' cutest features. Who could say no to these dandelion fluff faces?

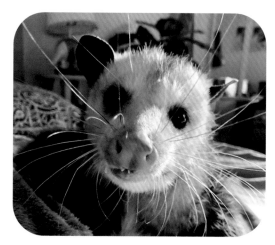

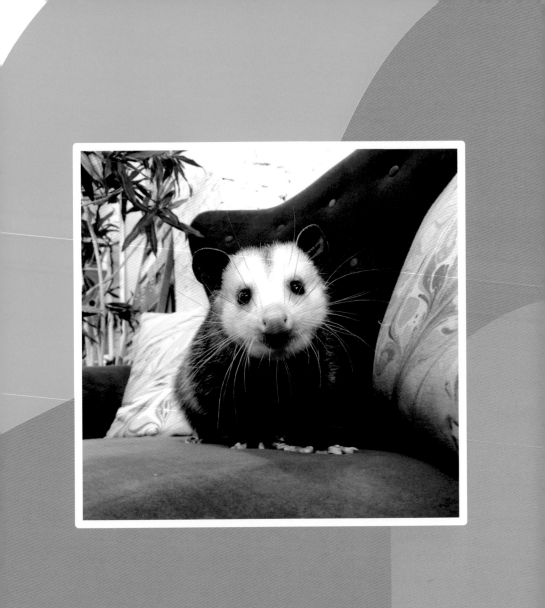

Presidential Possums

In 1892, President Benjamin Harrison requested two possums for himself at the White House. They arrived in a box, as reported in the *Sully County Watchmen* newspaper at the time:

The other morning two fine young 'possums were received at the White House. These were delivered by Adams Express Company and were in a box marked: "To the President: Two citizens of Maryland—Mr. Protection and Mr. Reciprocity."

They were sent compliments of John R. Howlett, a small-town Illinois politician who evidently simply wanted to fulfill Harrison's request. Each possum had a red, white, and blue ribbon around its neck, one personalized with the name Protection and the other with Reciprocity.

There are conflicting accounts and evidence as to whether Mr. Protection and Mr. Reciprocity were intended as pets, as claimed by the Presidential Pet Museum website or meals, as speculated by some of Harrison's contemporaries. At least one major newspaper at the time painted Harrison's request for possums as a political move intended to court the Black vote; possum and sweet potatoes was a dish then associated with southern Black communities. Regardless, many accounts state that Harrison kept the possums as pets in the White House and even took them on a transcontinental railroad trip during his presidency.

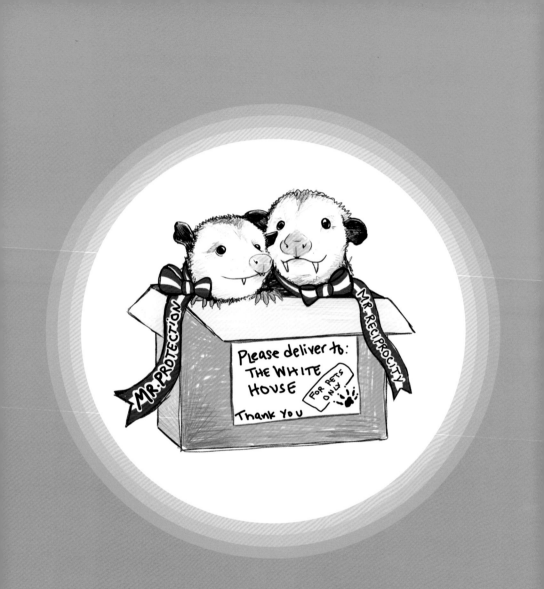

Ears

Baby possums' ears start out very light colored and darken as they age, with the tips of the ears being the last to turn black. Like a whale's tail, the particular darkening pattern of a possum's ears is unique to each individual and can help rehabbers distinguish between babies who might otherwise look identical. I've relied on this distinguishing feature many times—every single baby possum will tell you they haven't been fed yet; telling the babies apart from each other helps identify the fibbers.

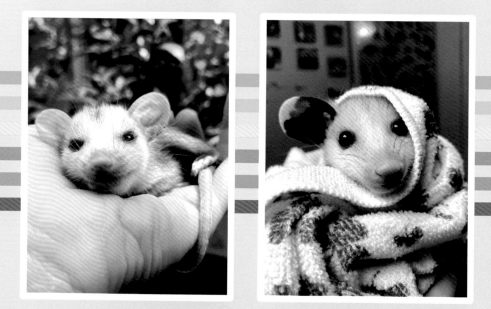

Perusing social media, you might even see baby possums sporting animal-safe paint or nail polish on their ears. Marking each baby with a different color is another way for rehabbers to tell who's who in a passel of possums. Identifying ear art ensures that each baby gets the right amount of food, medicine, and attention. But possibly the cutest thing about possum ears is that the outer part of the ear often folds down when they sleep, which keeps insects and foreign objects out of their ear canals.

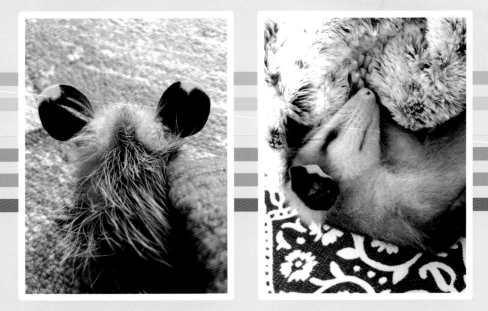

Tails

You knew it was coming. Time to talk about ... *That. Tail.*

Contrary to popular belief, possum tails aren't wet, slimy, or even naked. Adult possums' tails are rough and dry and have a corncob appearance made by small plates of epidermal keratin. Between these plates are fine, light-colored hairs. Babies have smooth and "grabby" tails, each one like a silky pink hair elastic. Because possums grow so fast, in less than a year their tails can feel like boa constrictors covered in tree bark. Do these tails serve a purpose (besides breaking jewelry and knocking over plants at four in the morning, as wildlife ambassadors are prone to doing)? Yes! But before we explore what possum tails can do, let's clarify what they *don't* do.

Some of the cutest cartoons of possums show them sleeping upside down like bats, hanging from branches by their tails. Sadly, possums don't sleep like that. Baby possums can support their full body weight with their tails and might be caught dangling from branches while still learning to climb, but adults cannot support their weight with their tails. Doing so for any prolonged amount of time would cause considerable pain and possible spinal injury. That said, possum tails are prehensile, meaning possums can voluntarily wrap them around trees or poles and use them like a fifth limb and safety harness.

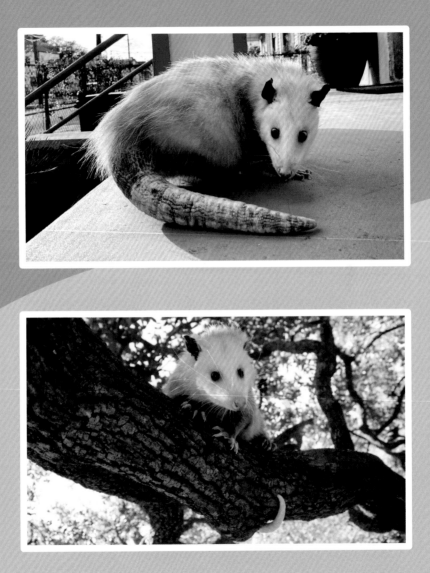

Possums also use their tails to transport useful materials. They collect leaves and other soft matter to be used as bedding by using their back feet to kick the material into their curled tail, which they spiral toward their body to create a loop the material will stay in. When the bedding is secure, they carry the bundle back to their den and curl up in their newly soft bed.

While a possum's tail is a vital tool when scaling treetops and schlepping leaf "blankets," it has yet another purpose: energy storage. Like lizards, possums store fat in their tails, which can help them get through the lean winter months, during which they don't hibernate but do slow down. As with eye fat, female possums are more likely to accumulate tail fat than male possums, an adaptation that affords them extra energy stores for all the hard work of reproduction.

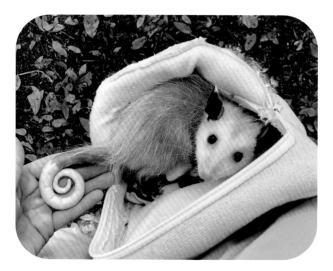

"GOT MY PILLOW AND BLANKET.
WHERE'S THE SLUMBER PARTY?"

Hands and Feet

Like most everything else on a possum, possum paws are very practical. Their forepaws (aka "hands") have five digits that can spread 180 degrees, giving them excellent tree-gripping powers and super stability. With their nimble fingers and star-shaped hands, possums can scale tree trunks and stand securely on branches. Their dexterity also helps them grab and hold their food while eating.

But it's their hind feet that are truly spectacular. Each foot has four digits and a clawless, opposable thumb, much like a tiny human hand. Not only are possums' back feet great for climbing, but the four little digits form a perfect hair comb for grooming. Perhaps the strangest part of possum paws is that they have unique fingerprints, just like human hands. Possums also have an additional fingerprint on a pink pad at the very end of their tail.

You'd think the potential of leaving prints might discourage possums from committing crimes. Unfortunately, possums don't care about consequences or getting caught.

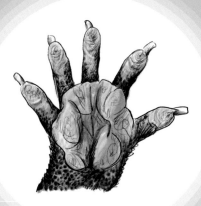

FRONT HANDS

BACK FEET

(WITH OPPOSABLE THUMBS)

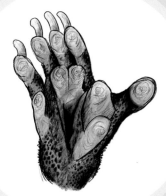

IMPOSSUMBLY FASCINATING FACTS

The Possum Rainbow

Although the majority of Virginia opossums are a silvery gray, possums come in a wide variety of colors. Darker coloring is common in locations nearer to the equator, a phenomenon called Gloger's rule. Several genetic anomalies, however, can result in an appearance far beyond the typical spectrum.

Possums can be born with albinism, resulting in bright white fur and pink eyes and ears. Leucism is another condition that results in all-white fur, yet leucistic possums retain dark eyes and all-black ears. A cinnamon variation of leucism, like Cornelia displays on page 59, occurs when there is noticeable yellow in their coloring. Possums can also be melanistic, giving them an all-black appearance except for their candy-pink noses. In addition to all this color variation, possums can also have alopecia, or hair loss. This baldness can be genetic or caused by environmental factors such as diet or stress. When a hairless baby possum named Peach (*opposite*) was dropped off at South Plains Wildlife Rehabilitation Center in Lubbock, Texas, in 2020, the community donated tiny sweaters to keep her warm.

A final note on fur: possum fur glows neon pink under black light! Researchers aren't sure what purpose the phenomenon—known as biofluorescence—serves. It may relate to camouflage and evading predators, or it may send important signals to other possums. Maybe it just looks good at parties?

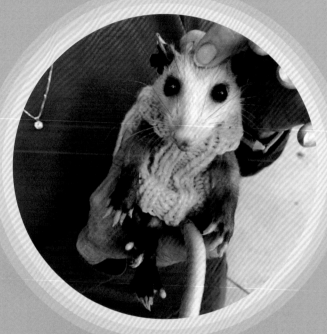

PEACH LOOKING COZY AND DAPPER AT
SOUTH PLAINS WILDLIFE REHABILITATION CENTER

Teeth

Possums have fifty teeth, the most of *any* land mammal. Fortunately, despite their intimidating appearance, these teeth are mostly used for climbing, grooming, and scavenging, not for chomping on innocent humans or pets.

Possum fangs are classified as prehensile, which means they help possums grab onto branches while climbing, giving these animals another tool in their impressive climbing toolkit alongside their hands, feet, and tail. And what about those two tiny teeth in the front? What purpose could those possibly serve? They're used for picking delicate berries and fruits from branches and for catching ticks while grooming.

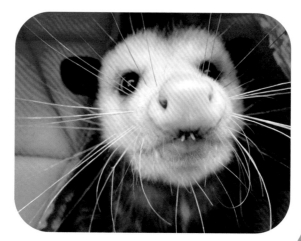

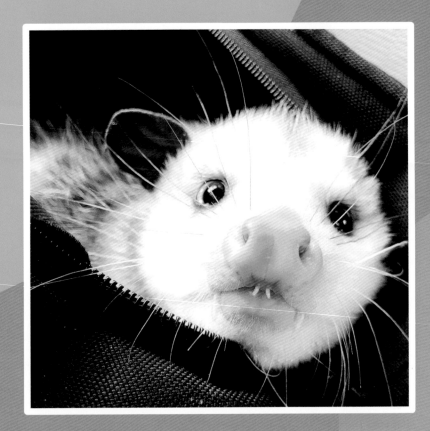

Pouches

The most remarkable feature of the possum may just be their pouch. It's what makes the possum a marsupial. There are 334 known species of marsupials in the world—200 of them in Australia and nearby islands, 133 in South and Central America, and only one (by now you know which) in the US and Canada.

Possums give birth to embryonic young following a gestation period of just thirteen days. Once birthed, the tiny, undeveloped, honeybee-sized critters make the long journey through their mother's fur and into the pouch, following a scent path the mother licks for them.

The pouch is not nearly as private or sensitive as it might seem. It's akin to any mammal's underbelly, just with extra fur-lined skin to protect the young while they nurse and mature.

When the possum babies find the pouch, each newborn claims a nipple. Possums have a circle of twelve nipples, with a thirteenth in the center. When an infant latches on, the nipple stretches spaghetti-thin and swells in the infant's stomach, effectively anchoring it for six to eight weeks as it grows. Incidentally, this is a big reason why baby possums need a trained rehabber to feed them: very young possums must be tube-fed to mimic the distinctive way they would nurse with their mother.

At around three months old, possum babies are mature enough to detach from the nipple and go on short explorations outside the pouch. When they are between three and four months, they'll

BABY POSSUM GROWTH CHART

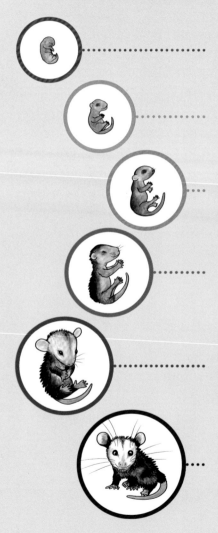

Birth–1 Week
5–10 GRAMS, SIZE OF A HONEYBEE.
EMBRYONIC, HAIRLESS AND PINK. HAS
RUDIMENTARY ARMS TO HELP CLIMB INTO
MOTHER'S POUCH TO BEGIN NURSING.

1–2 Weeks
10–15 GRAMS. ATTACHES TO A LONG
NIPPLE AND NURSES IN THE POUCH.

2–3 Weeks
15–20 GRAMS. WHISKERS BEGIN TO
GROW. SKIN DARKENS FROM PINK TO
GRAY. NIPPLE ELONGATES TO ALLOW
MOVEMENT IN THE POUCH.

4–5 Weeks
20–25 GRAMS. FUR BEGINS TO GROW.
NOTICEABLE EYE SLIT. STILL NURSING.

6–9 Weeks
25–40 GRAMS. FULL FUR GROWS IN.
MOUTH AND EYES OPEN. NOT ATTACHED
TO A NIPPLE BUT STILL NURSING.

10–16 Weeks
40–400 GRAMS. ABLE TO EAT
INDEPENDENTLY. ACTIVE AND EXPLORING.
LEAVES THE POUCH AND RIDES ON
MOTHER'S BACK.

leave the pouch for longer periods, even climbing onto their mother's back while she walks around. As they get bigger, they spend more time aboard the mom bus and less time packed into the pouch. Riding piggyback on their mom gives them a front-row seat from which to learn about the outside world. If one of the babies falls off or becomes separated from the family, it will call to the mother with a little sneezing sound that lets her know the baby went overboard and needs to be scooped back up.

Speaking of sneezes, for a long time it was thought that possums mated through the female's nose and that once impregnated, the female would sneeze her young into her pouch! Possum reproductive life is weird enough without imaginative rumors like that. For instance: the males have forked penises that correspond to the females' two uteruses.

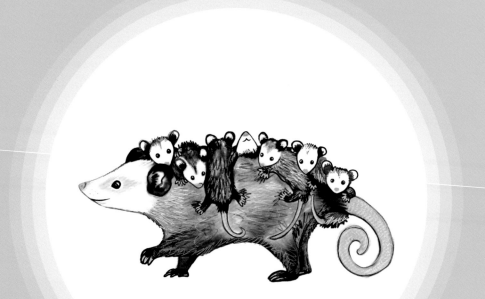

ALL ABOARD THE MOM BUS!

Brains

Even people who like possums might have the impression that they're not bright. Their ponderous waddle, blank stare, and tendency to freeze at a challenge don't scream Einstein. But the idea that possums have an inferior intellect is one of the most persistent—and unfounded—myths they face. Possums can (and often do!) outperform their animal peers in tests of intellect. In his articles on possum adaptability, biologist Steven N. Austad highlights possums' superior food-finding cognitive abilities, noting that "when tested for ability to remember which of four runways was connected to a food box, opossums scored better than cats, chicks, dogs, goats, pigs, rabbits, rats and turtles, although less well than humans."

That's a huge accomplishment! And yet, even researchers' praise of possums is often accompanied by backhanded compliments. As Austad summarizes, "their small brain and dullness notwithstanding, opossums have a remarkable talent for finding food and remembering where they found it."

There is *one* truth lurking among the generally erroneous statements about possum intelligence, and that is that their brains are impressively small. While possums and cats have similar body and head sizes, a cat's brain is typically five times larger than a possum's. A cat's brain is also structurally different in that it has the wrinkles associated with intellect, whereas the possum brain is—you guessed it!—smooth as a grape. Of all mammals,

possums boast one of the most meager brain-to-body ratios. The possum brain case is only big enough to hold 25 dried beans (cats' can hold 125 and raccoons' 150).

Smooth brained as they are, possums accomplish a lot with so little. In 1963, animal behaviorists W. T. James and William Turner conducted a study of seven juvenile possums and determined that they made fewer mistakes while learning a maze than adult rats, who by contrast are often lauded for their intelligence. After decades of research, James acquiesced that "the surprising result is that the opossum is highly successful in all types of learning situations."

That's the possum for ya—exceeding incredibly low expectations!

'TIS A NOBLE MIND THAT APPRECIATES AND UNDERSTANDS ART.

Though possum intellect has clearly been unfairly mocked, the truth remains that perhaps possums excel at tasks like finding food and navigating mazes because they don't clutter their brains with abstract and impractical thoughts. In the 1977 book *Biology of Marsupials*, biologist Don Hunsaker notes that "possums tend to live a very opportunistic life which is not complicated by a high level of memory, negative responses, and complex avoidance reactions of places or things." Ignorance truly is bliss! Or, at least, ignorance of the negative things and a hyperfocus on the positive, like snacks, leaves little room for anxieties and existential crises.

Unburdened by overthinking, possums live in the present worry free. That's a lesson we could all take to heart.

**LIVING WELL WITHOUT A JOB,
AND ALMOST NO MONEY,
IS THE POSSUM WAY.**

POSSUMS THROUGHOUT HISTORY

Forget Teddy Bear—Meet Billy Possum!

Several US presidents have been confirmed possum fans, but President William Taft took possum mania to the next level, though whether he was a "fan" is debatable as his fandom centered around hunting and serving them for dinner by the hundreds. In 1909, Taft's "Possum Committee" organized a huge possum dinner in Atlanta, Georgia. Because possum was associated with the cuisine of southern Black communities—it was plentiful, free, and filling—some believed that Taft was courting the Black vote with his entrée choice, and critics mocked him for the lavish display. The dinner entertained over six hundred white male guests in their finest suits, and the occasion was documented in a dramatic group portrait.

Inspired by the dinner and sensing a commercial and political opportunity, Taft fans and associates attempted to launch a competitor of Roosevelt's namesake teddy bear named Billy Possum. A campaign took off, and ads, postcards, pins, and other possum paraphernalia were designed to market and drum up interest in the thousands of "little possums" being produced by the newly formed Georgia Billy Possum Company. Sadly, Billy Possum was not a success. Some have suggested Billy's failure to capture hearts can be attributed to his questionable origin story—the story of a possum killed and served at dinner is not quite as charming and cuddly as Teddy Roosevelt's story of a bear magnanimously pardoned during an afternoon hunt.

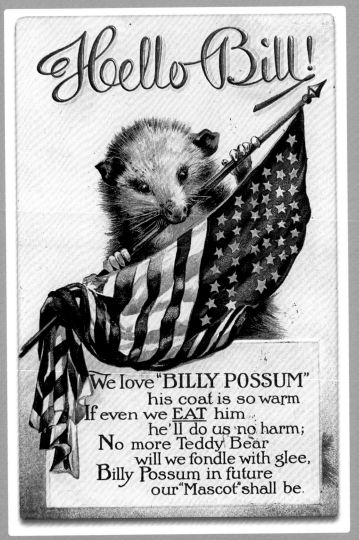

A PROMOTIONAL POSTCARD FEATURING BILLY POSSUM FROM 1909

Possums Are **DANGEROUS!**

As wild animals, possums deserve their space and should never be cornered or antagonized. But the idea that possums are destructive, violent, and dangerous is a myth. In fact, they protect humans and pets from many diseases and pests.

If you've ever unexpectedly encountered a possum in your neighborhood, you might have been startled by its many teeth, aggressive hissing, bulging eyes, and generally terrifying appearance. While possums can look menacing, the truth is they are most likely frightened and attempting to avoid confrontation. It's a sad truth that possums' unique defense mechanisms give rise to misconceptions about these shy creatures that harm their reputation and make their lives even more challenging—the introvert's catch-22.

It needs to be stated that under no circumstances should anyone approach or put themself at risk of being bitten by a wild possum. Possums have sharp teeth and strong jaws, and a bite from *any* animal can become infected and pose a risk to your health. A bite can also result in the frightened animal losing their life, as some states require the euthanasia of any wild animal that has bitten a human. Be careful! Keep those fingers out of possums' gator mouths. That said, let's dispel a whole lot of myths about the risk possums pose to pets and humans.

THE FACE OF A MONSTER.

Possums eat pets!

When a beloved cat goes missing or a dog returns from outside with a limp, it can be tempting to think the neighborhood possum is responsible. In reality, there are many reasons why a possum should be low on the suspect list. When possums are scared, their first instinct is either to freeze or to slowly and awkwardly waddle away. But if they can't escape a threatening situation, they may bare their teeth, sway back and forth, and let out a low, rumbling growl to make them appear as dangerous and intimidating as possible. With their knife-like teeth and *Exorcist*-style snarling, they can appear absolutely demonic. And they *will* bite if cornered! The only smart thing to do when faced with a frightened wild possum is to let them be (unless they need help, in which case please contact a wildlife rescue immediately). But on the whole, their scary act is just that—an act—and they are highly unlikely to instigate fights with people or pets.

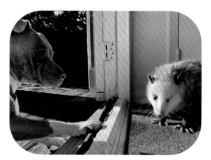

Possums need protection too.

All in all, it's fairly safe to say that a possum is way more frightened of you, and your pets, than you should be of them. In fact, while adult possums and dogs or cats can usually coexist peacefully, baby possums can be in mortal danger around domestic pets. Scurrying about and appearing like little snacks, young possums excite dogs and trigger the hunting instincts of cats. In wildlife rehabilitation centers, baby possums are often admitted with cat or dog bites. Some don't survive their injuries and many others are left with permanent paralysis and other significant complications. The best way to help possums—and all wildlife, for that matter—is to keep cats indoors (with plenty of exercise and stimulation, of course) and dogs leashed or closely supervised.

IMPOSSUMBLY FASCINATING FACTS

Playing Possum

If acting like a belligerent demon doesn't scare away a predator, a scared possum has a few other tricks up their sleeve. The next step is to play possum, or fake death, in the hope that the threat will be fooled and move on. Much like the coping mechanism of so-called fainting goats, whose muscles uncontrollably seize when startled, a possum's fatality fake-out is entirely involuntary. The frightened possum falls over and drools, pulling their lips back in a ghoulish grin. Their heart slows to a near stop, and a pungent odor emits from glands under the tail, making the possum smell as if they're already in the throes of decomposition. Just as a possum can't control this torpor, they also have no say in when they snap out of it. They can appear dead from around forty minutes to four hours. If you come across a possum who looks deceased, please be aware that they may be in this comatose state. If they're in danger and especially if there are babies in the pouch, contact your local wildlife rescue for assistance.

Possums carry diseases!

We've established that the possum in your yard is more likely to be prey than predator and is not truly planning its attack against you or your pets (despite creeping on your fence and staring vacantly at your house). So why are they always hanging around? Honestly, it's because they love people! Well, not people so much as the food and shelter that come with people. Given that they are wild animals who love to be near humans—and that they look like rodents of unusual size with bulgy eyes who growl when cornered—it's no wonder people have concerns about possums and disease. But the fears that possums are disease vectors are unfounded. That said, all animals can carry harmful diseases, and wild possums should never be handled except by trained professionals.

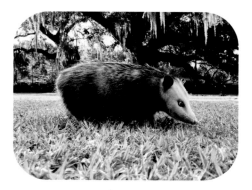

HAPPY, HEALTHY, AND CRUISING FOR SNACKS

Possums defend us from disease.

The misconception that possums are vectors of disease is perhaps one of the most unfair myths plaguing possumkind. In fact, possums *protect* people and pets from disease. A single possum can eat 95 percent of the ticks they encounter, or up to four thousand ticks a week—the very ticks that transmit diseases like Lyme, babesiosis, and Rocky Mountain spotted fever. Such tick-borne illnesses have devasting consequences for people and pets, so having possums on anti-tick patrol is invaluable from a public health standpoint.

Besides eating all these ticks, a possum itself is unlikely to carry a disease that's threatening to humans. One of the most concerning viruses that mammals can transmit to humans—the dreaded rabies virus—requires a host with a relatively warm body temperature in order to survive. While it is not impossible for possums to carry rabies, their average body temperature of around 94 to 97 degrees Fahrenheit makes infection extremely rare. This relatively cool body temperature also prevents possums from being hosts to distemper, feline hepatitis, and parvovirus, which will be a major relief to anyone with dogs and cats in their family.

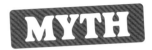

Possums are dirty!

Possums are fastidious groomers—which will come as a surprise to people who think of them as dirty, stinky trash dwellers. Despite hanging out in rubbish bins and eating food that is often expired at best (it's what makes them such great sanitation engineers!), possums maintain a high level of cleanliness. In fact, they spend much of their waking time cleaning themselves, using their back feet to comb their fur. It's during this process that they catch ticks that have landed on them. They'll grab the intruders with their toes and gobble them up.

Another way possums clean themselves is with their tongues. Possum tongues are rough like a cat's, and long, which isn't all that surprising given how long their faces are. Possums wash their faces by licking their hands and rubbing them over their cheeks, eyes, and forehead. They clean their papery ears by pulling each one through their hands. The rest of their body gets a thorough lick-down; they end up looking like pointy cats as they stretch into obscure poses to get those hard-to-reach places.

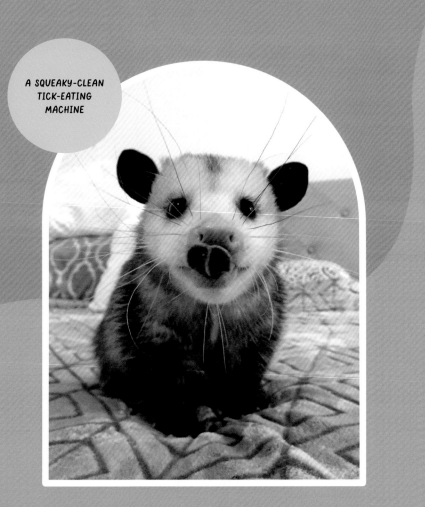

A SQUEAKY-CLEAN TICK-EATING MACHINE

Possums are bathing beauties.

Considering their meticulous cleaning habits, it might surprise you to learn that rescue possums still need a bath from time to time. This is because possums are a bit like a mix between a cat and a dog—like cats, they love to groom themselves, but like dogs, they can't resist covering themselves in questionable fragrances from the great outdoors (most likely to cover their own faint scent from predators and prey alike). Male possums have musky scent glands on their chests (and all possums have anal glands that can smell terrible when expressed), so while possums are generally free from natural body odor, a little masking ensures they can throw other animals off their scent. Possums also scent mark in an activity called slubbing, in which they rub their cheeks on anything they want to trade smells with. This is another way they pick up smells to mask their own odor. Seizing every opportunity to bring natural stinks indoors after outdoor playtime is why some wildlife ambassador possums might end up in the tub.

POSSUMS THROUGHOUT HISTORY

Go, Team Possum, Go!

In 1929, President Herbert Hoover was just beginning his term as president when a White House police officer found a possum on the premises. Hoover adopted the possum and put him up in a pen that Hoover's immediate predecessor, President Coolidge, had built for his pet raccoon Rebecca. Paying homage to President Taft, who was associated with possums after his lavish possum dinner and ensuing plush toy (see page 76), Hoover named his possum Billy Opossum.

Billy's legacy is immortalized not just in portraits snapped on the White House grounds but also in letters and the media coverage of the day. Students at Hyattsville High School in Maryland wrote to Hoover inquiring whether Billy Opossum might be the same possum that ran on the field in a recent game and delivered their baseball team a win. Hoover suggested Billy was probably not that possum but offered to lend his services as a mascot, which the students gratefully accepted. The school won many games that season, and when the possum was returned, Hoover promised that Billy's success "will be incorporated into his service record."

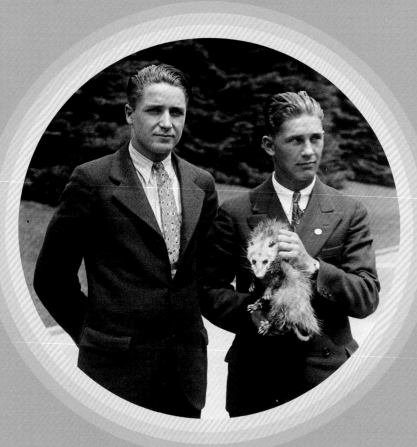

HYATTSVILLE HIGH SCHOOL STUDENTS ROBERT VENEMANN (LEFT) AND
WILLIAM ROBINSON HOLDING BILLY POSSUM AT THE WHITE HOUSE IN 1929

Possums are pests!

When the subject of possums comes up, my friends in animal control can be counted on to lament the copious calls they get from homeowners who want possums removed from their yards. "I tell them the possum is probably doing a better job of pest control than I can," one friend recently said. Possums eat venomous snakes, cockroaches, mice, rats, edible garbage, carrion, and basically anything else they can find, and as such they are an integral part of the North American ecosystem. Sure, they can frustrate gardeners who find some of their juiciest fruits and vegetables missing, but possums also love eating the various beetles, slugs, snails, and other invertebrates that damage gardens. A tomato or two is a small price to pay for free and ecofriendly pest control!

Having a possum as your friendly neighborhood pest warrior is *way* safer and more effective than other methods like glue traps—which are inhumane and indiscriminately capture bugs, mice, birds, and baby possums—and poison, which can kill entire food chains of native animals. Larger animals such as owls, eagles, and bobcats, not to mention pets, can eat poisoned "pests" and become poisoned themselves. The quickest, cheapest, and most humane way to a pest-free neighborhood is to let possums do what they do best.

Possums are nature's toughest bouncer.

One of the most amazing things about possums is that they are immune to the venom of pit vipers—including rattlesnakes, cottonmouths, and copperheads—and they put this superpower to good use by eating these venomous snakes. According to Steven N. Austad, the diet of possums in certain regions of Texas consisted of 6 percent copperheads, which is a large percentage for an animal who eats nearly everything.

In fact, scientists are studying the peptides in possum blood to develop a low-cost rattlesnake antivenom. If keeping viper populations in check and helping humans survive rattlesnake bites doesn't impress you, the fact that possums also gobble up scorpions (they are immune to scorpion stings) should put this peerless protector in anyone's good graces.

In short, if you could choose to have a security guard on your property defending you and your furry loved ones from tick-borne illnesses, mice, roaches, scorpions, and venomous snakes, you could find no better bouncer than a possum.

SUPERPOSSUM:
ENVIRONMENTAL HERO

POSSUMS THROUGHOUT HISTORY

Possum Pandemonium

In the 1970s, possum pandemonium took hold in Alabama. A man named Frank Basil Clark founded an organization called the Possum Growers and Breeders Association of America (PGBAA). The group paired possum fandom with a big dose of performance art—to such an extent that many contemporaries, and people since, have been unsure of whether or not it was a joke. Membership in the association cost five dollars and recruits received a bumper sticker in the mail that read EAT MORE POSSUM.

Farce or not, the association and its bumper stickers were wildly popular. By 1972, the PGBAA reportedly had 30,000 members, including President Richard Nixon. By 1988, the PGBAA claimed to be 164,000 strong, with former presidents Ronald Reagan and Jimmy Carter and the then vice president, George H. W. Bush, amongst its ranks. Though the movement was popular, it failed to accomplish its stated goal of curing world hunger with possum meat. In a win for possums, the environment, and economists who tout a plant-based diet as the way to achieve equity in food access, the possum escaped disaster and slinked off to pursue its never-ending quest to be left alone.

Possums are antisocial!

If you've ever seen a possum in the wild, chances are it was on its own (unless it was a mom with babies). Because of this, and because possums are so shy and avoidant, they're perceived by many as antisocial grumps who shun even their own kind. But underneath their gruff exteriors, possums are quite affectionate. Nonreleasable possums will cuddle with humans, but in the wild young possums especially love cuddling with their siblings. Young possums enjoy the warmth and comfort of one another's presence and are at their healthiest and most content together.

Although adult possums can pose a threat to unrelated youth (they might mistake babies who aren't their own for prey), adult females may occasionally adopt and nurse unrelated infants and welcome orphaned juveniles.

As evidence continues to grow, it appears that even adult possums hang out with each other more than originally thought. In 1991, biologist Donna J. Holmes observed possums living in an enclosed but naturalistic habitat and found the majority of their interactions were friendly (aside from squabbles during mating season) and that they established matriarchal and lasting social hierarchies akin to those of more stereotypically social animals. Holmes even found that unrelated possums chose to den together in both cold and warm temperatures, suggesting their cuddling is not only for protection but also for affection.

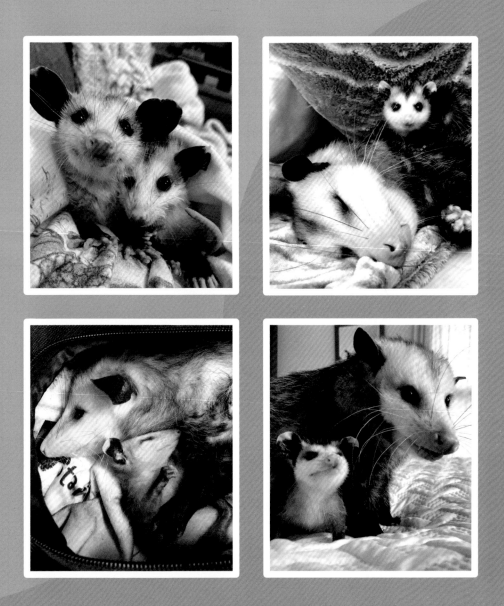

The possum is a friend to all.

Possums are also quite comfortable with making interspecies friendships. While they are opportunistic omnivores and may occasionally try to eat their smaller friends, they are pacifists at heart and avoid threatening animals their size or larger. Adult possums have even been found to cohabitate with animals of other species. Possums are wanderers who don't dig or construct their own shelters, choosing instead to carry leaves in their curled tails and sleep anywhere that looks safe and comfy, including in dens carved out by other animals. In the 1940s, researcher Daniel W. Lay found that possums have a particular fondness for armadillo dens. He noted several occasions of possum-armadillo odd couples cohabitating, suggesting that armadillos don't mind having possums crash on the couch.

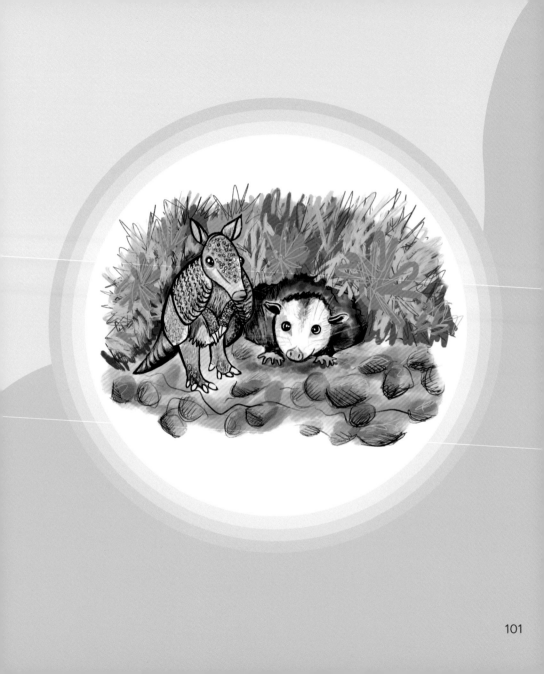

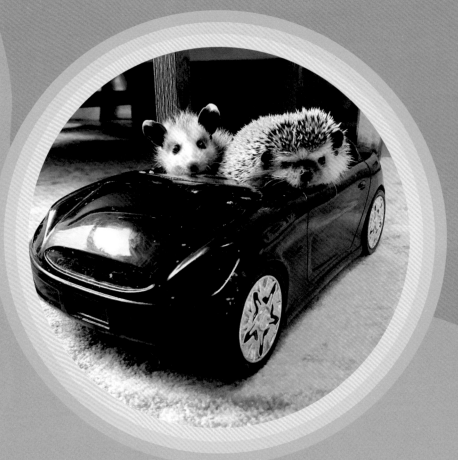

BAGUETTE AND
KEVIN THE HEDGEHOG

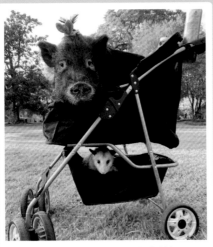

STARRY AND PHOEBE THE PIG

STARRY AND STARRY THE OWL, A NONRELEASABLE AMBASSADOR AT
WILDSIDE REHABILITATION AND EDUCATION CENTER

The ultimate irony is that although possums are seen as dangerous, disease-laden delinquents, they are in fact the opposite. They are gentle, sweet stewards of the environment, protectors of people and pets, and well-mannered (except when frightened) friends with a very Zen approach to life. There's not much that fazes them—certainly not snakes or scorpions—and they're very happy to share a bed (provided they don't have to make it themselves).

Live Fast, Make Young

In the wild, possums only live an average of one year, and even when cared for as wildlife ambassadors, they typically live about three years maximum. Why do they age so quickly?

The answer can be boiled down to one word: predators. Possums have natural predators like owls and hawks, but possums' most dangerous threats come from human activity—the worst danger of all being cars. By causing the demise of so many possums on roadways, humans have been unknowingly selecting for possums that mature and procreate quickly. Those who don't procreate quickly often get run over before passing on their genes to the next generation.

In 1993 Steven N. Austad, chair of the biology department at the University of Alabama at Birmingham, studied an isolated population of Virginia opossums on Sapelo Island off the coast of Georgia and found that these island possums not only live longer but also have fewer babies per litter than their mainland peers. Austad concluded that island possums mature and age more slowly because historically they have faced fewer threats like cars, hunting, and coyotes.

If it weren't for humans unwittingly breeding them to live in the fast lane, would America be filled with elderly possums, leisurely enjoying a golden age of ten, fifteen, twenty years? It's nice to dream. But in the meantime, see page 109 for advice on how to look out and care for possums on the road.

How to Be
a Possum
CHAMPION

Independent as possums are, everyone needs a helping paw from time to time. There are many things you can do to support your friendly neighborhood possums.

Now that we know all the ways in which possums are great, it's time to learn how to protect, support, and champion the possums in your own neighborhood.

Although you want to give wild possums their distance, you can still help them thrive in your yard. Possums don't migrate or hibernate, so leaving out fruit (their favorite!) and fresh water—especially in winter—won't disturb their natural instincts and may in fact help them survive. If you're able to grow edible gardens, even better!

Although possums seem indestructible, they're actually quite delicate and tragically unfit for chilly weather. As they gradually expand their range northward, they're finding themselves farther from milder southern winters, encountering frostbite and food scarcity. Possums in all climates are usually very grateful for food, water, and warm, dry shelter. A doghouse or the space under your porch might be the perfect hangout for them. You'll be rewarded for your efforts with superior pest control and charming (and very toothy) smiles.

Conversely, if you'd rather keep possums away for whatever reason, you can easily dissuade them from sticking around by making sure all trash is in covered, locked bins and keeping the yard clear of debris. A lack of anything edible and no leaves or lawn clippings to use as bedding will encourage them to seek food and shelter elsewhere. But why turn down a friendly face and free pest control?

You can also help possums by keeping an eye out for them on roads. Because possums are largely nocturnal and not very fast, they're at high risk of being hit by cars. Driving slowly and carefully, especially at night, is one of the best things you can do for possums (and yourself!).

If you find an orphaned baby or babies on the road, please contact a local rescue and follow their advice to get the young possums to safety. Baby possums without a mother who are less than seven inches long (not including their tail) have the best chance of survival with a rehabber.

If you encounter an adult possum who is injured or appears deceased, exercise caution! Remember that possums may appear dead but can reanimate at any moment (see page 84). Do not bury them or leave them in the path of danger. Call your local wildlife rescue for advice.

STARRY DOING HER BEST TO KEEP WARM IN THE COLD WEATHER

Possums Aren't Pets!

If possums are so great, does that mean it's time to scoop one up and make it a pet? NO!

Firstly, this is not fair to possums, who deserve a life in the wild whenever possible. Remember all the great things possums do for the ecosystem? Possums need to be wild in order to fulfill their destiny as America's environmental cleanup crew. Wild possums have lives full of adventure, mating, babies, and more, and it's not fair to deny them their birthright when they can thrive outdoors. The instances in which possums live indoors as wildlife ambassadors involve individuals with disabilities that preclude them from living a wild, natural life. Several US states have laws against keeping wild animals as pets. These laws are in place to protect both people and wildlife, and they truly serve the greater good. Just because a president—or a few presidents—did it doesn't make it right.

Secondly, possums are high-maintenance and require copious time, research, and resources to be effectively cared for. Their veterinary bills alone are through the roof! Trying to match the nutrition they find in the wild is costly and labor-intensive, and an incorrect diet invites dire consequences that often cannot be reversed. Possums also enjoy strolling miles every evening, and even those who are cared for by rehabbers struggle to stay healthy and get regular exercise on par with what they would experience in the wild.

THIS MUCH CUTENESS CANNOT BE CONTAINED!

Time, expense, and effort notwithstanding, possums will also get into *everything.* If cats pushing things off counters for no reason at all is inconvenient for you, you don't want to see what a possum can do. When it comes to breaking every valuable, possums are like supercharged cats (and they love causing a ruckus at night). They seek out anything strongly scented: coffee, dried herbs and spices, gummy vitamins, toothpaste . . . When I first began rehabbing, I learned to hide all my toiletries after finding teeth marks in every bar of soap I left out in the open.

That said, there are few activities more rewarding than rehabilitating these wonderful creatures. If you have the inclination, I suggest volunteering at a nearby wildlife rescue or beginning the process of becoming a rehabber yourself. You can start by reaching out to your nearby rescue center and asking how you can help. Not only will you be making a huge difference for possums, but your assistance and efforts will doubtless be appreciated by the rescue staff.

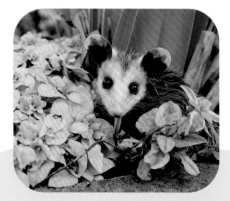 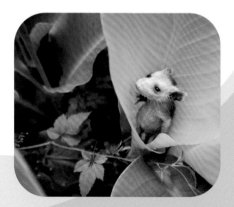

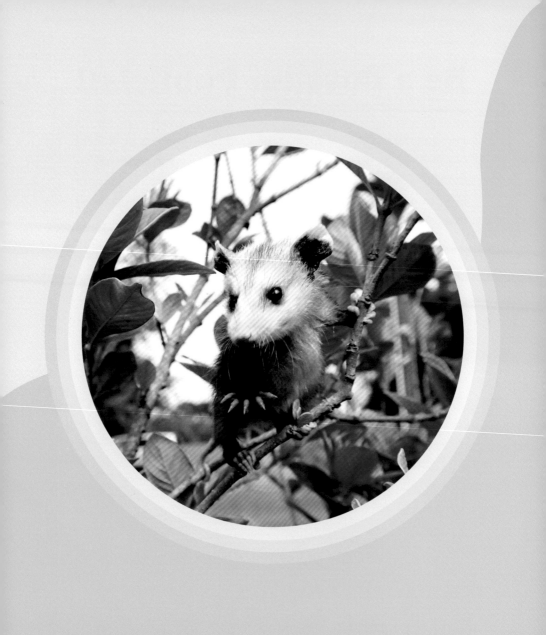

Be a Possum Publicist!

Perhaps the easiest yet most important thing you can do to help possums is to spread the possum gospel. Use the information in this book and your own personal insights to convince others how unique, helpful, and important possums are to the ecosystem (and how cute they are, too). More than ever, native wildlife needs to be protected, celebrated, and recognized for the hugely important role each animal plays in the environment. That's especially true for possums, who, as we know, bring balance by gobbling up ticks, cockroaches, snakes, trash, and carrion. The harmful myths that have plagued possumkind have resulted in hostile and unfriendly treatment from humans, and the sooner such attitudes change, the faster these gentle underdog heroes can do their important work in peace.

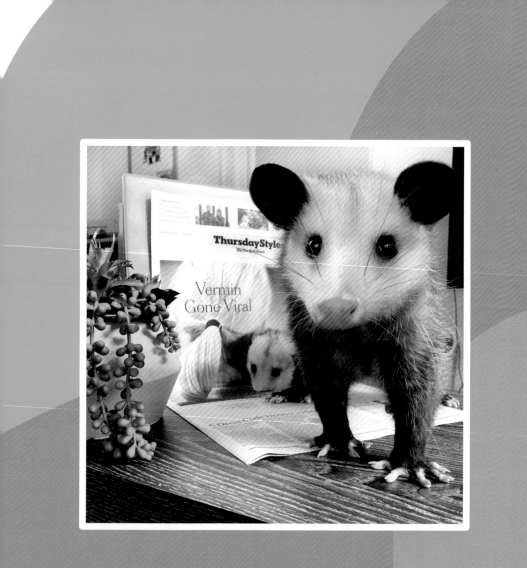

CONCLUSION:
The Future Is Possum

From social pariahs to social media stars, the future for possumkind looks bright.

For much of history, the prevailing attitude has been that possums are at best a minor inconvenience and at worst vermin to be eradicated. Few and far between have been the people who appreciated them, and even then, many have shown their "appreciation" by either keeping possums as pets or eating them. Thankfully, there are many possum lovers today who have found a much gentler and more animal-friendly way to appreciate possums.

A small but powerful grassroots community of meme lovers on social media are fans of these so-called pointy kitties and trash animals—singing possums' praises and spreading the word of their environmental benefits.

Young people around the world see themselves reflected in the possum—those shy, awkward, scrappy, anxious introverts who are so easy to relate to.

These fans are starting conversations, making their yards and neighborhoods wildlife friendly, and celebrating North America's only marsupial in their daily habits and interactions.

When I think about possums' popularity today, my mind goes back to the curtains I noticed in the glamper where I met Sesame. At the time, I wondered where one would even find possum fabric. When I searched online, Google seemed confused by the request.

Now, possums are trending and popping up everywhere. And the excitement around them has nothing to do with trying to eat them or turn them into a political fad. It's all about appreciating them for who they are—their personalities, quirks, and idiosyncrasies. Our brain cases may be able to hold ten thousand dried beans (compared to possums' twenty-five), but it's possible we entirely missed the point on the possum. We've spent so long exploring whether and how possums could be used to benefit people that we missed everything they naturally do for us, and our duty to consider what we can do for them. Possums are finally being noticed and appreciated for all the things they've been all along but that we humans were too oblivious to see.

"What even *is* a possum?" is a question humans have asked ourselves from the beginning, from baffled settlers encountering them for the first time to my three-year-old niece, who insists every possum she sees on FaceTime is a dog. No matter who you are or your background or era, you can likely agree the possum is on par with the platypus in being one of the most wonderfully bizarre creatures to ever grace the earth.

Their inherent strangeness is somehow amplified by their ubiquity—nearly everyone in America has a possum story, and yet, as creatures of the night, it's easy to forget they exist.

They're our roommates who work the night shift, whose existence we would probably forget about if it weren't for our things occasionally going missing, the crumbs left after a midnight snack, and the infrequent but memorable instances in which we accidentally cross paths.

Celebrating possums elicits the joy of discovering something that's been there all along, a kindred spirit right in our own backyards.

What does the future hold for possums? Who knows! Let's hope the days of being dinner are behind them, along with the myths of possums being ugly, dumb, inconsequential, diseased, and aggressive. Will they be appreciated for their environmental benefits, their gentle nature, their unique place in our history, and their incredible physiology? Perhaps. One thing's for certain: possums are masters of adaptation and survivors worthy of admiration. In 2011 Inés Horovitz of the Department of Ecology and Evolutionary Biology at UCLA told Natalie Angier, a science writer for the *New York Times*, that

Every time I see an opossum I get moved. They've managed to survive all this time looking the same as their ancestors did 60 million years ago or more.

Possums have thrived despite many harmful attitudes and actions against them. Like cockroaches and shelf-stable snack cakes, they might well outlast us all. After treating them unfairly for so long, perhaps we owe it to them to make their wild lives just a little easier. And why deny ourselves the joy of finally appreciating them? We have nothing to lose and everything to gain by making a new friend.

Selected Bibliography

For a complete list of references consulted, visit
quirkbooks.com/possums.

Angier, Natalie. "A Fast Life and Success That Starts in the Pouch." *New York Times*. June 13, 2011. https://www.nytimes.com/2011/06/14/science/14angier.html.

Austad, Steven N. "Retarded senescence in an insular population of Virginia opossums (*Didelphis virginiana*)." *Journal of Zoology* 229 (1993): 695–708. https://doi.org/10.1111/j.1469-7998.1993.tb02665.x.

Banks, Joseph. *The Endeavour Journal of Sir Joseph Banks, 1768-1771*. Sydney, 1962. https://gutenberg.net.au/ebooks05/0501141h.html.

"Benjamin Harrison's Mr. Reciprocity and Mr. Protection." Presidential Pet Museum. Accessed 2021. https://www.presidentialpetmuseum.com/benjamin-harrisons-mr-reciprocity-mr-protection.

Eastman, Charles R. "Early Portrayals of the Opossum." *American Naturalist* 49, no. 586 (October 1915). https://www.journals.uchicago.edu/doi/pdf/10.1086/279504.

Hartman, Carl G. *Possums*. Austin: University of Texas Press, 1952.

Holmes, Donna J. "Social Behavior in Captive Virginia Opossums, *Didelphis virginiana*." *Journal of Mammalogy* 72, no. 2 (May 24, 1991): 402–10. https://doi.org/10.2307/1382114.

James, W. T., and William W. Turner III. "Experimental Study of Maze Learning in Young Opossums." *Psychological Reports* 13, no. 3 (December 1, 1963): 921–22. https://doi.org/10.2466/pr0.1963.13.3.921.

Krause, William J., and Winifred A. Krause. "The Opossum: Its Amazing Story." Department of Pathology and Anatomical Sciences, School of Medicine, University of Missouri. January 2005. https://www.uaex.uada.edu/environment-nature/wildlife/docs/The_Opossum_Its_Amazing_Story.pdf.

Lay, Daniel W. "Ecology of the Opossum in Eastern Texas." *Journal of Mammalogy* 23, no. 2 (May 14, 1942): 147–59. https://doi.org/10.2307/1375067.

Martyr of Angleria, Peter. *The Decades of the Newe Worlde or West India* [. . .]. Translated by Richard Eden. London, 1555. https://quod.lib.umich.edu/e/eebo/A20032.0001.001.

Ostfeld, Richard. *Lyme Disease: The Ecology of a Complex System.* Illustrated edition. New York: Oxford University Press, 2012.

Smith, John. "A Map of Virginia. With a Description of the Countrey, the Commodities, People, Government and Religion." 1612. In *John Smith*, edited by Edward Arber, 43–84. New York: Burt Franklin, 1910. https://encyclopediavirginia.org/entries/a-map-of-virginia-with-a-description-of-the-countrey-the-commodities-people-government-and-religion-by-john-smith-1612.

Strong, Travis. "Vision in Opossums." Email to author. April 28, 2019.

Troughton, Ellis. *Furred Animals of Australia.* New York: C. Scribners's Sons, 1947.

Acknowledgments

This book is only possible because of the countless opossum lovers who have contributed to and continue to improve our societal and scientific understanding of these magnificent creatures. From the rehabbers who spend days and nights tube-feeding baby opossums, to biologists researching opossum physiology and behavior, to fans on social media who share memes and beautifully creative fan art, every bit of engagement and activism has provided the foundation upon which this book's message of opossum positivity is built.

It became apparent to me early on that the Sesame the Opossum community is special: passionate, fun-loving, and not afraid to be a bit unconventional. Comprising people from every age and background, our friends on Facebook, Instagram, and YouTube and our extraordinary supporters on Patreon all turned what could have been an isolating experience—caring about an animal who is often maligned—into an incredible experience of learning, growing, and seeing life through the eyes of opossums together. I am so grateful to each and every one of you. Thank you.

Many in the Sesame family are fellow rehabbers. I'd like to thank the hundreds of wildlife rehabbers and professionals who have welcomed Sesame and his friends with open arms. Victoria Clark, a wildlife rehabber and animal care professional, has graciously offered her expertise and patience, whether at 4 p.m. or 4 a.m. I also owe Leah Andressen of Silent Voices Raccoon and

Wildlife Rehabilitation a huge debt of gratitude, for believing in me and being an inspiration. Jeff Dorson of the Humane Society of Louisiana has also been supportive and inspirational in his tireless creation of a compassionate, kill-free society where the lives of all animals are valued. Scott Sweren is an amazing friend and colleague, and I don't know what I'd do without him.

I send gratitude to my agent, Sorche Fairbank, who believed in and advocated for this book from the beginning, and to Rebecca Gyllenhaal and the team at Quirk Books, who joined the journey and enhanced the premise and content in countless ways. Creating this book has been a group effort, and I'm grateful to the publishing professionals and new friends who contributed their own visions, creativity, and expertise to create a unique and joyful ode to opossums.

To my immediate family—my parents, Jan and Tom, and sisters, Elizabeth, Victoria, Genevieve, and Juliette—I owe a thank-you that can hardly be expressed in words, but I'll try. Thank you for always making me feel accepted, loved, and valued. Thank you for making life an extraordinary adventure and navigating all the twists and turns as a team. You've shown me unconditional love and always encouraged me to be myself—even when that means a house full of opossums—and I hope I reflect the same love back to each of you.

About the Author

Ally Burguieres never intended to specialize in possums, but here we are. She was born in Washington, DC, and raised in Bethesda, Maryland, and she fell into possum advocacy after studying sociolinguistics and establishing herself as an artist and writer. She earned a master's in journalism from the University of Oregon, another master's in language and culture from Georgetown University, and finally a doctorate in sociolinguistics from Queen's University in Belfast, Northern Ireland. She taught courses in new media with Tulane University, where she explored social media and content creation with students of all disciplines.

Along with her family, Ally owns three shops in New Orleans dedicated to her animal artwork—one called Gallery Burguieres and two called Cocoally—and the online Sesame the Opossum merch shop. On Sesame's social media channels, she shares surprisingly cute possum photos and stories while educating about and advocating for these beautiful creatures. Making a difference for possums wouldn't be possible without Sesame's friends and fans. Ally is forever grateful to all those who have joined Sesame's mission to change hearts and minds about the United States' only—and cutest—marsupial.

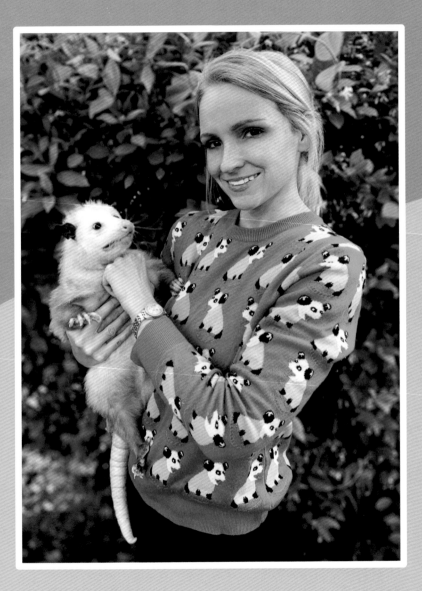

Photo Credits

All photos and illustrations are by the author except the following.

PAGE 9: Author holding baby Starry the Opossum. Photo by Thomas Burguieres, MD.

PAGE 51: The cross-eyed opossum Heidi, taken on December 14, 2010, at Leipzig Zoo. Photo by Hendrik Schmidt. Reprinted by permission of AP Images.

PAGE 65: Peach the Opossum in her custom sweater. Photo by Gail Barnes, director of South Plains Wildlife Center.

PAGE 77: Billy Possum postcard. Birn Brothers of London and New York, 1909.

PAGE 93: Hyattsville High School students Robert Venemann and William Robinson holding Billy Possum at the White House on May 25, 1929. National Photo Company Collection, Library of Congress Prints and Photographs Division, Reproduction Number LC-DIG-npcc-17484. Retrieved from the Library of Congress, www.loc.gov/item/2016843745.

PAGE 127: Author holding Cornelia the Opossum. Photo by Evie Burguieres.